MY (VERY) Colorful Cats

(and their kinda kooky stories and lessons)

By Debra A. Duff

Copyright © 2015 Debra A. Duff

All rights reserved

No part of this book may be reproduced in any manner whatsoever without written permission, except in the case of reprints in the context of reviews.

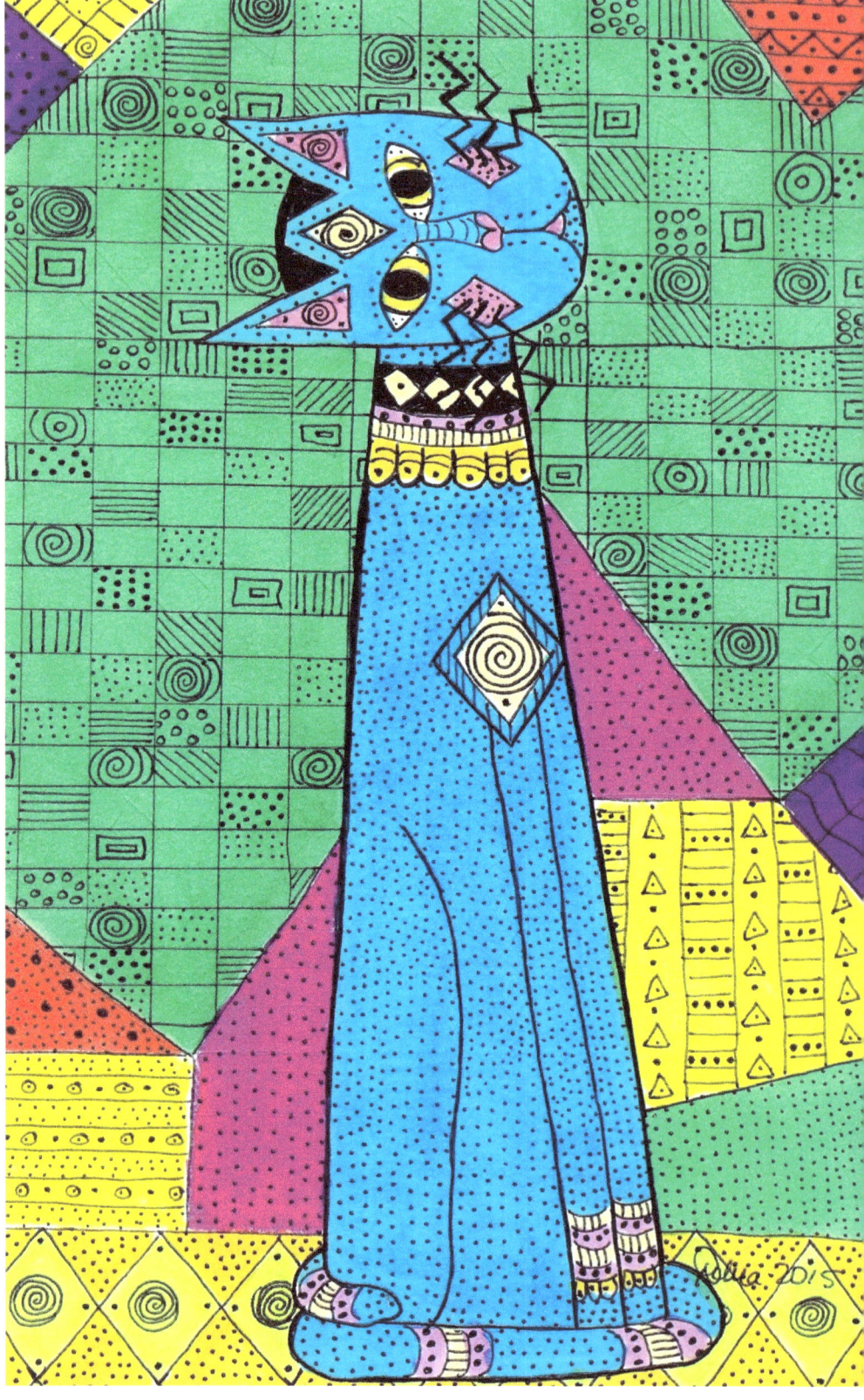

The Ancient Egyptians worshipped cats. Obviously, for our natural grace and poise, but you may not know that we also killed vermin and cobras and scorpions. In fact, civilization might not have survived if not for cats.

We earned the right to be held in such high esteem
And we have never forgotten that.

You shouldn't either!

Heap of Cats

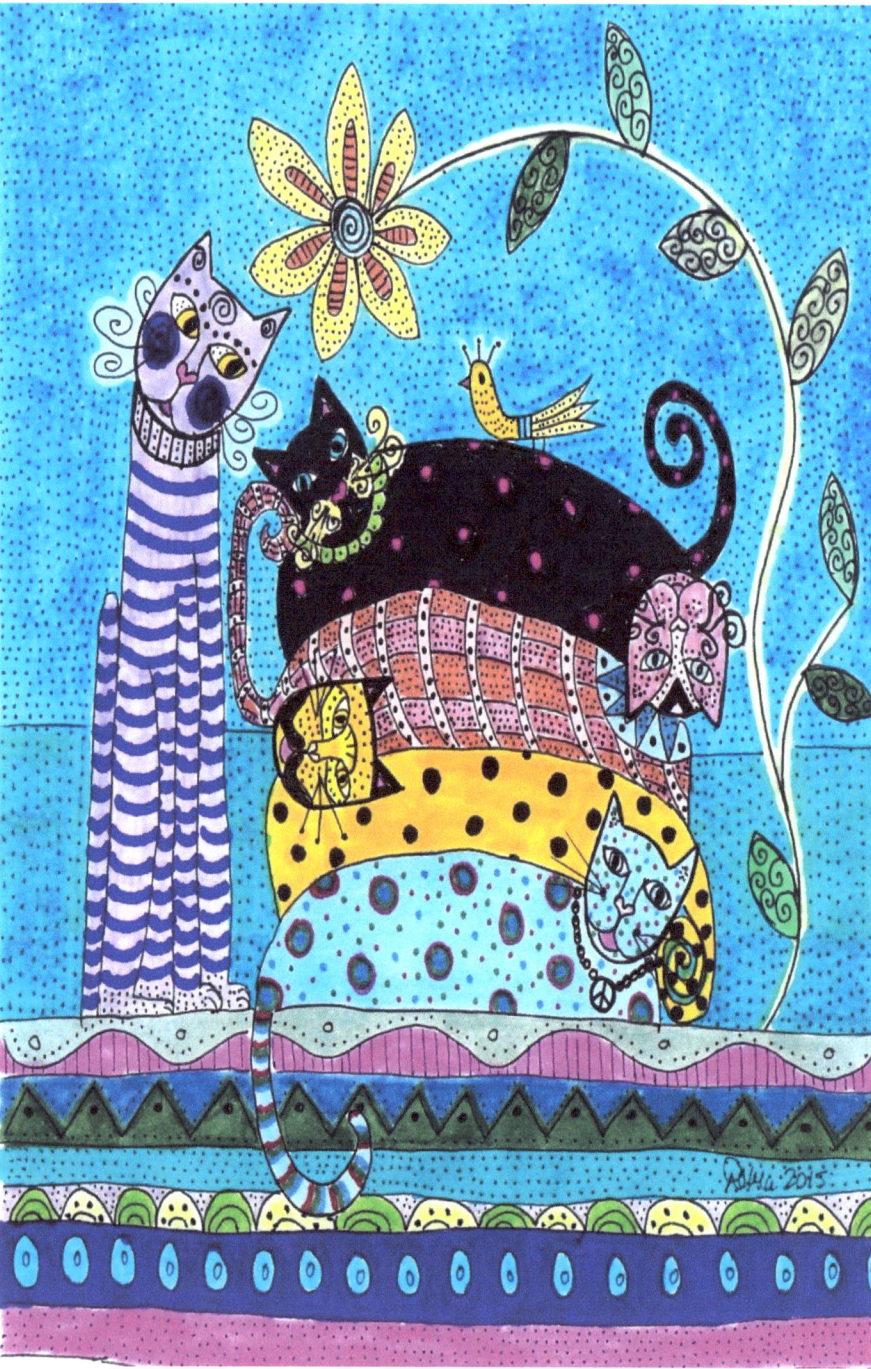

Purple Ms Murple would
like you to meet
her four cat friends,
who are all in a heap.
At the top of the pile is
the raven-haired Pip
who thinks she's all that
AND a bag of chips.
"With my beauty and charm
you can't possibly resist -
Which is how I arrived
at the top of the list."

Next in the pile
is my best friend Lyle.
give him an inch and
he'll take a mile.
Don't count on Lyle
to catch any mice -
he's a lover not a hunter
….he's much too nice.
And don't forget Dot
who loves to polka.
Somebody told me
she was born in Boca

and lived
in a big mansion by the sea,
but now she lives with my
human and me.
And last but not least is
Henry McHale
Who dresses real flashy
right down to his tail.
He's also an artist –
he just loves to draw.
Instead of a paint brush,
he uses his paw.

And I, Ms Murple,
am a lover of purple.
I think you'll agree that it
suits me purr-fectly.

Gypsy Cat

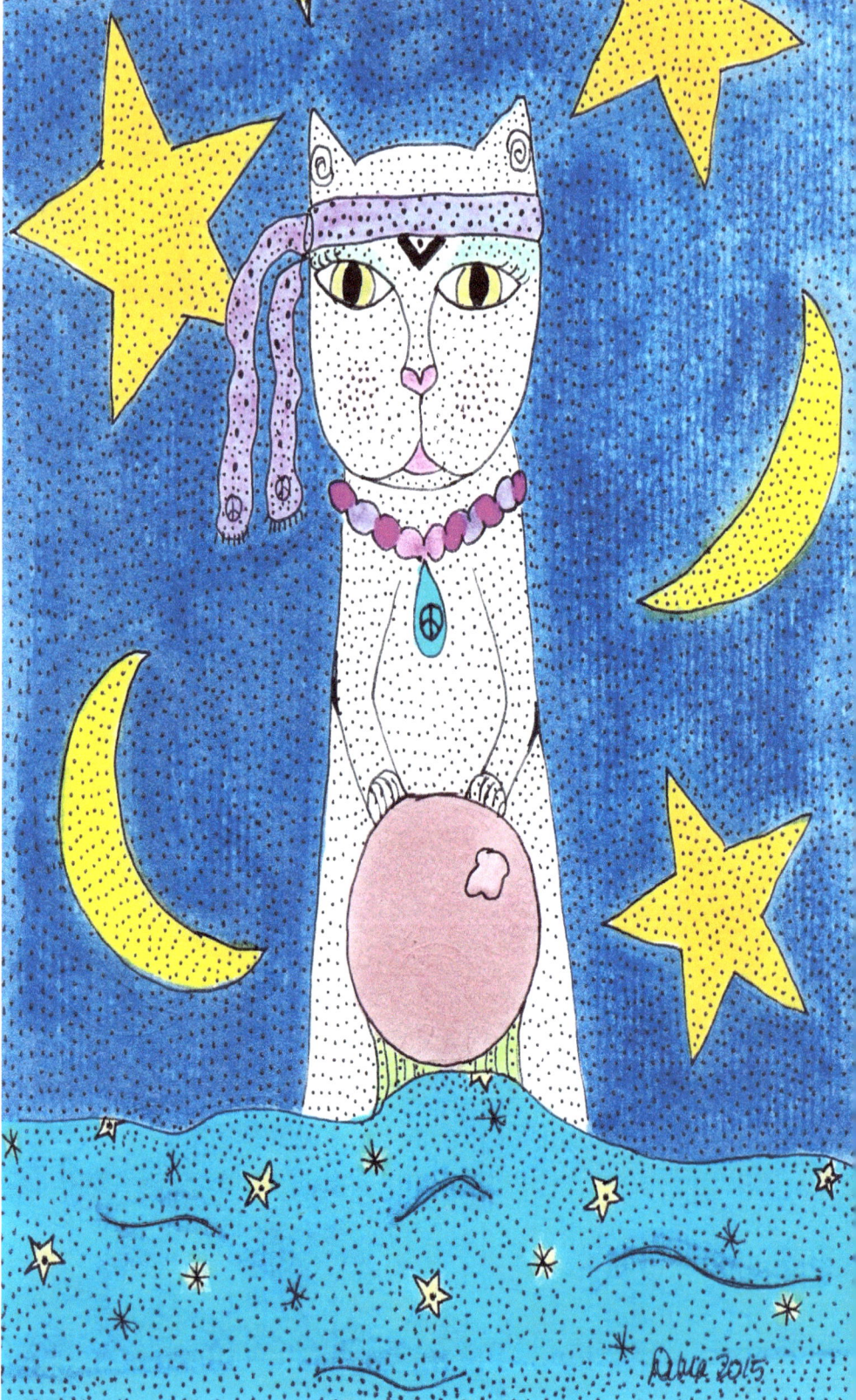

Gypsy Cat's got a crystal ball.
With it she can see it all.
Will your love life improve?
Will you win
the lottery this week?
She'll gaze into her
mystical orb
and give you
the answers you seek.

Like the time she told Lenny
he'd find a shiny penny.
So he kept looking
at the ground

till he ran right into Walt,
the grouchy basset hound.
Walt didn't take kindly
to the shock
and chased Lenny
down the block!

"I'm so sorry, Walt"
said Lenny,
"I'm really not blind.
I was looking for the penny
Gypsy Cat said I would find."

Take everything you hear with a grain of salt
Or you might do something stupid…
like run into Walt.

Fear

Of Spiders

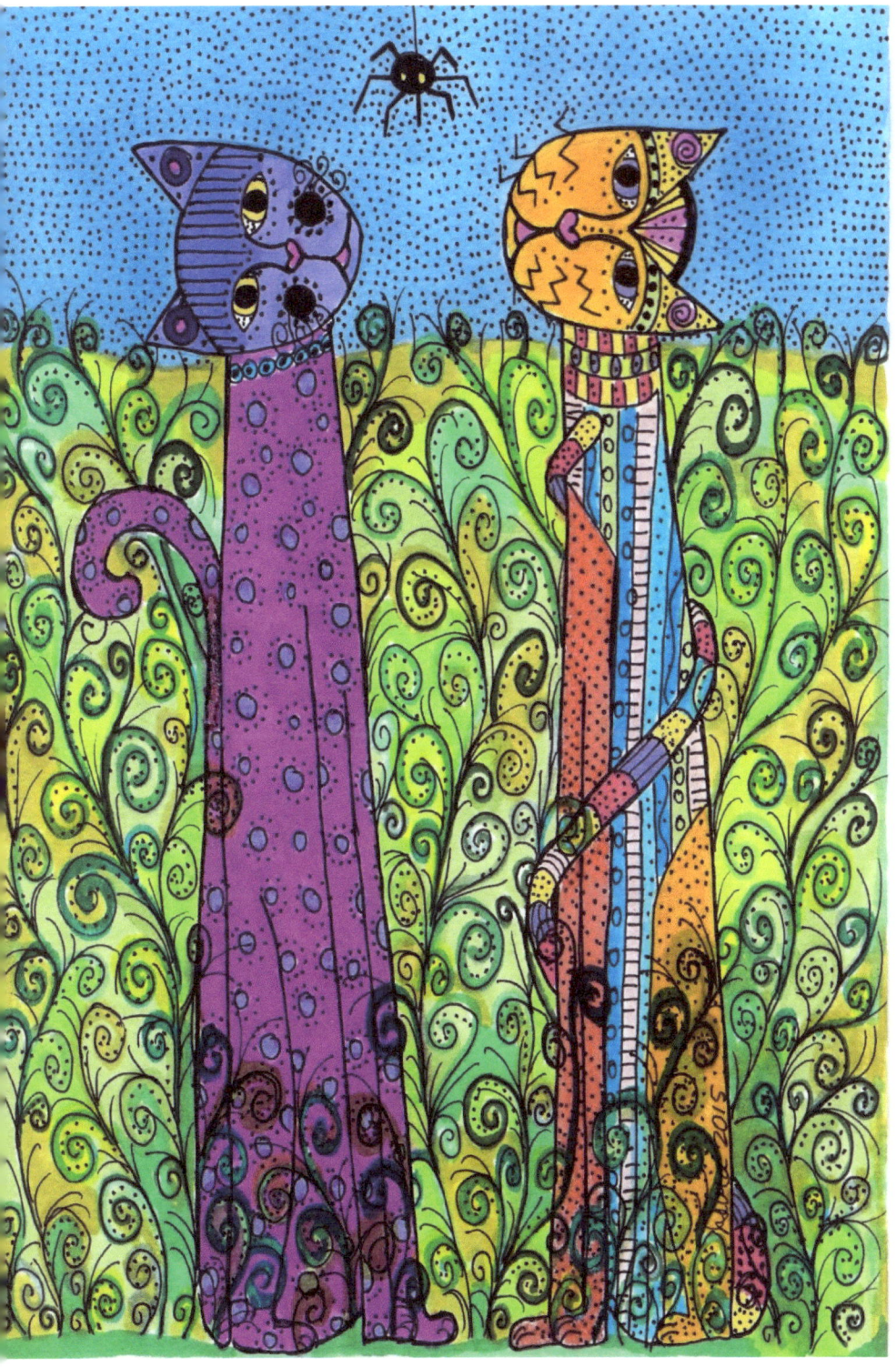

"That's no itsy bitsy spider,"
said Fanny to Fay.
And we're not eating
curds and whey.
So whatever we do,
don't draw attention.
I'm afraid of spiders,
did I happen to mention?"
"Don't worry, Fanny,"
said Fay.
"Have no fear.
That spider is way more afraid
of you, my dear."

So they watched as the spider
did his magic act
on a web of spun silk,
each strand exact.
Mother Nature does some
wonderful things -
like give spiders the ability to
make their own silly string.
They watched in wonder
all day long
And now Fanny's
fear of spiders is gone.

Four Little Kittens All in a Row

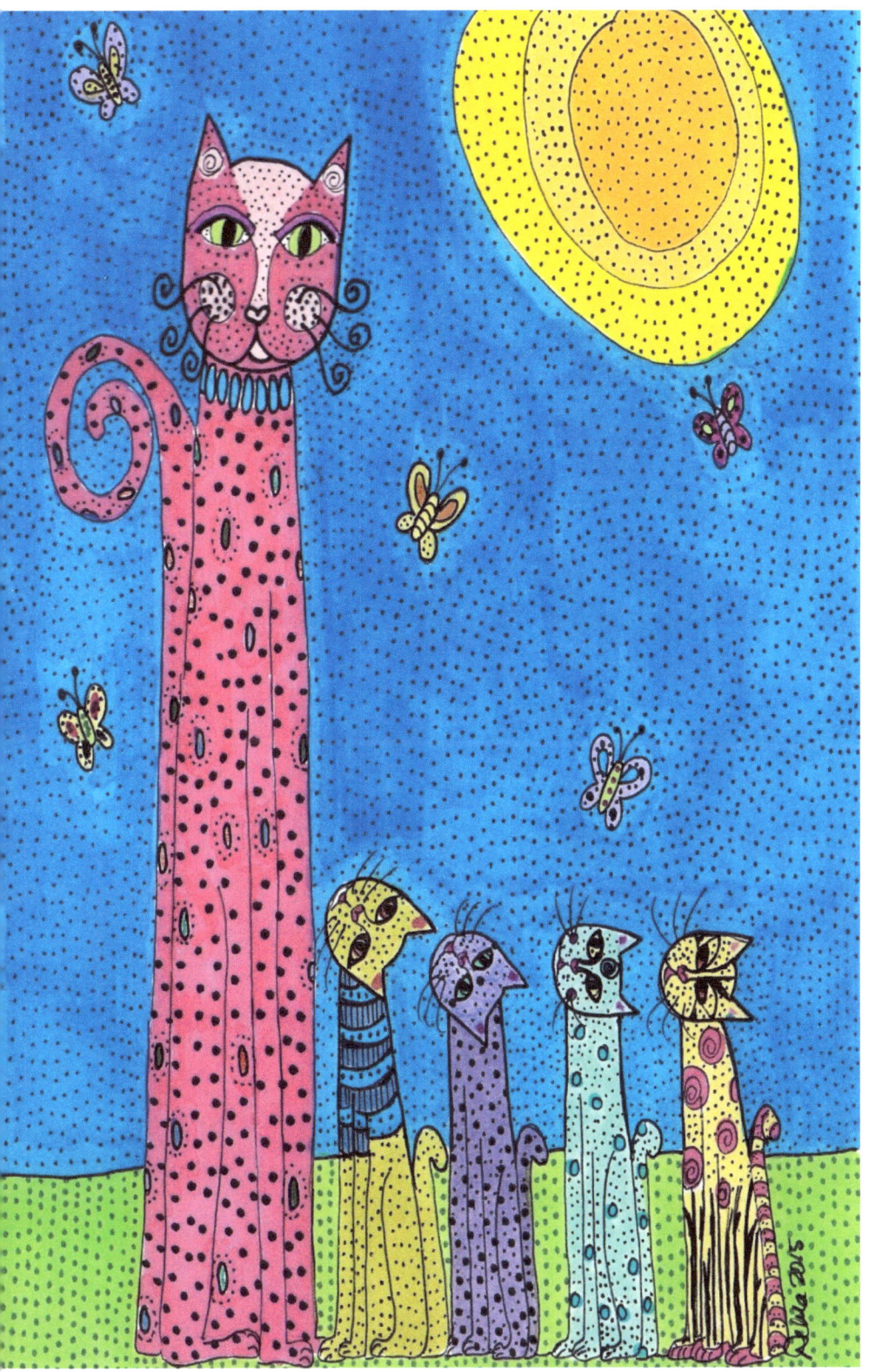

Four little kittens
all in a row….
Three little girls and
a boy named Joe.
They all cried "Momma,
it's such a nice day.
We want to go
outdoors and play."
Momma said "Okay,
but let me remind you -
last one out - close the door
behind you."

So out they went….

1… 2… 3… 4

but they forgot to close the door.

When they returned – to their surprise - Momma had made some catnip pies.

"Oh, catnip pie! Momma- it's so yummy!"

Joe and his sisters planned to fill their tummies.

But the neighborhood cats had already come since the door was left open and the pies were all gone! "Oh no! Oh no!", said the kittens that night. "Tomorrow we'll make sure the door is closed tight!"

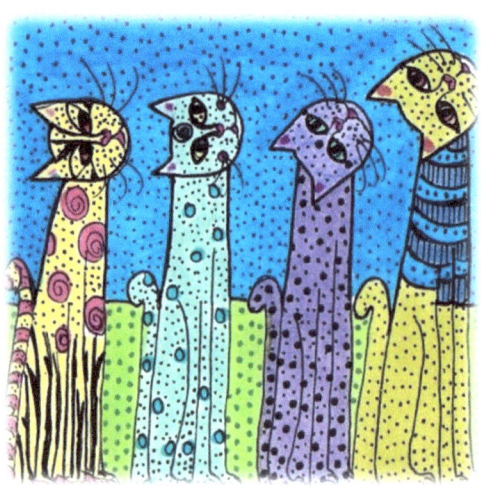

Pierre Le Chat

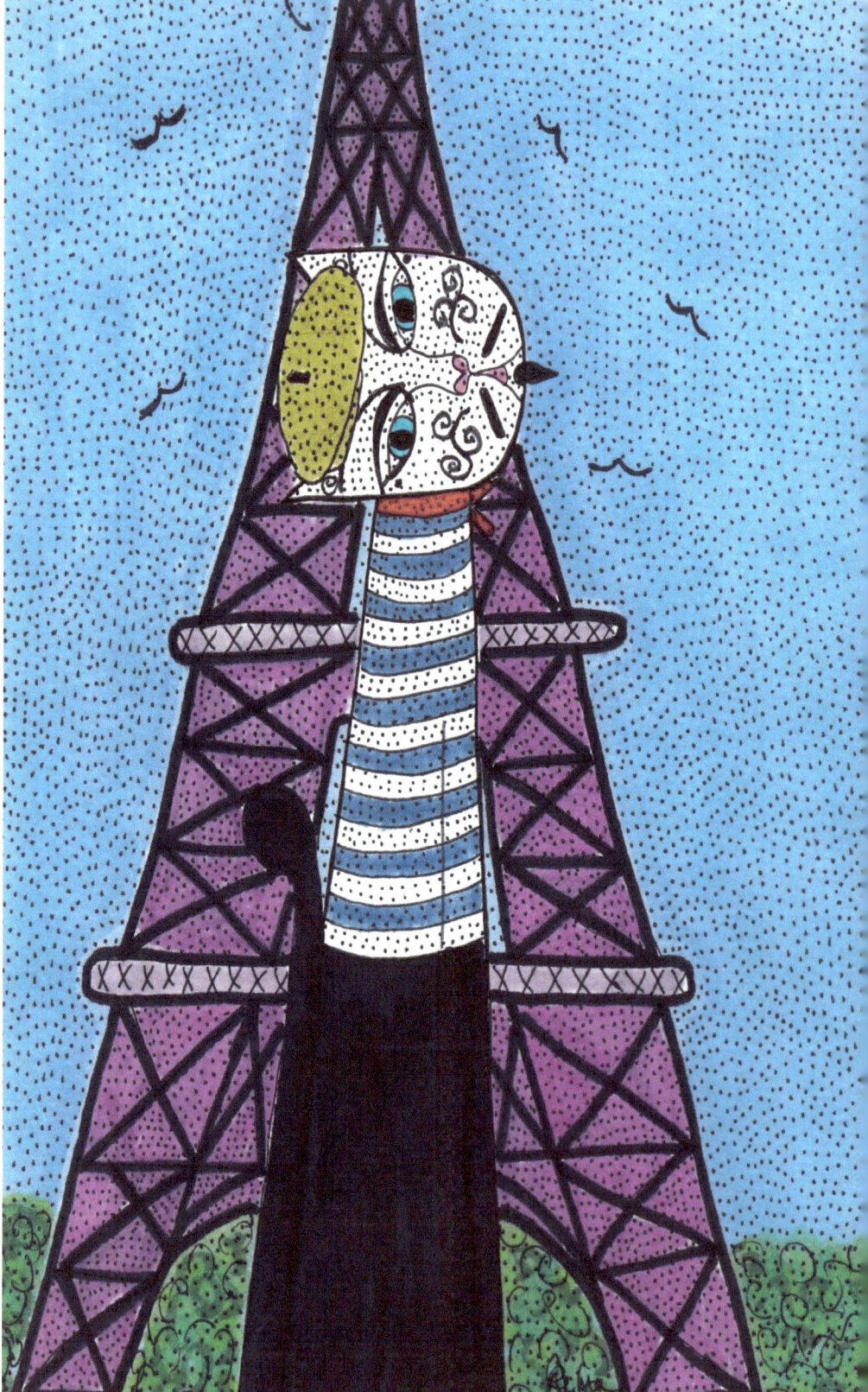

My name is Pierre LeChat -

I come from Paree.

I am a famous chef –

perhaps you've heard of me?

My specialty of course

is French cuisine.

I like to use lots of butter

and cream.

And tuna – lots of it –

since I am a cat.

Add a pinch of catnip –

you can't beat that.

When you taste my dishes

you will kiss my paw

Because all of my dishes

are ooh-la-la!

Raven

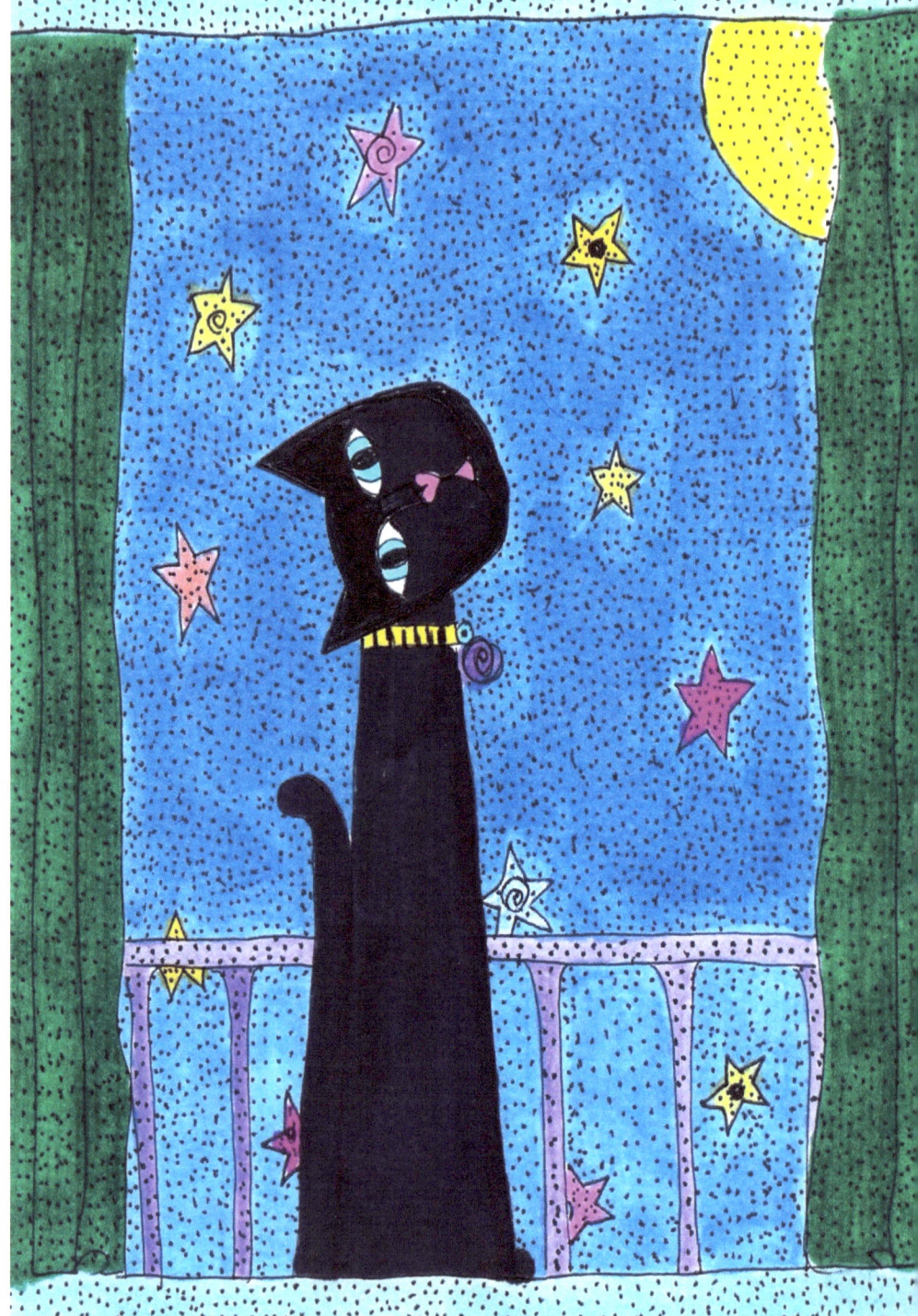

Raven is a night sky gazer who knows all the planets and stars. She fancies herself an astronomer of sorts and insists there is life on planet Mars. "They'll come visit us soon," she says matter of factly.

"And so will

the man in the moon.

I don't know when exactly,

but I'm told

it may be sometime in June."

Yes…...In her belfry

may be bats,

But we try not to cross

black cats

So we humor Miss Raven

and let her be.

After all, she may know

something more than we.

The Three Mustachioed Cats

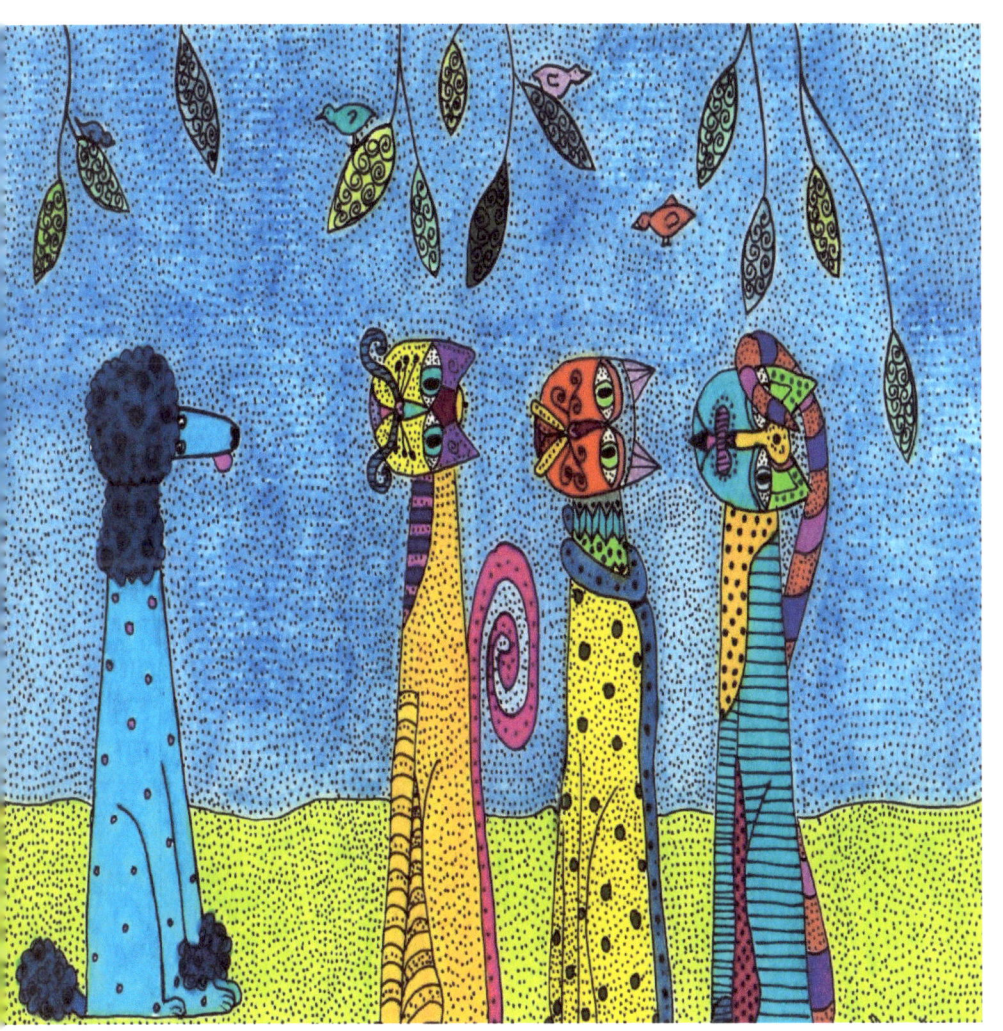

The poodle was out walking one day when he came across The Three Mustachioed Cats. They were the neighborhood bullies, so he had to stand pat. "Hey you guys, come play with me."

"You're joking I'm sure."

said Cat Number Three,

while One and Two

laughed hysterically.

"You're a dog!" One said.

"A poodle no less.

You're uncivilized and silly…..

you are one hot mess!

We only play games

like hunting for lizards

and climbing trees.

You wouldn't be able to do

either of these.

You pander to humans, with

your tail wagging

and your tongue hanging out

– you've no self-respect!

On the other hand,

we ignore humans, so what do you expect?" The poodle said sadly, "I just wanted to be friends, but you're not friendly at all!" Just then his human called out, "Poodle, do you want to go for a ride in the car to the mall?"

And the poodle was off
like the wind,
his pom pom tail wagging
every which way!
He jumped in the car and
woofed to himself,
"Who needs those bullies
anyway?"

The Kitty Family

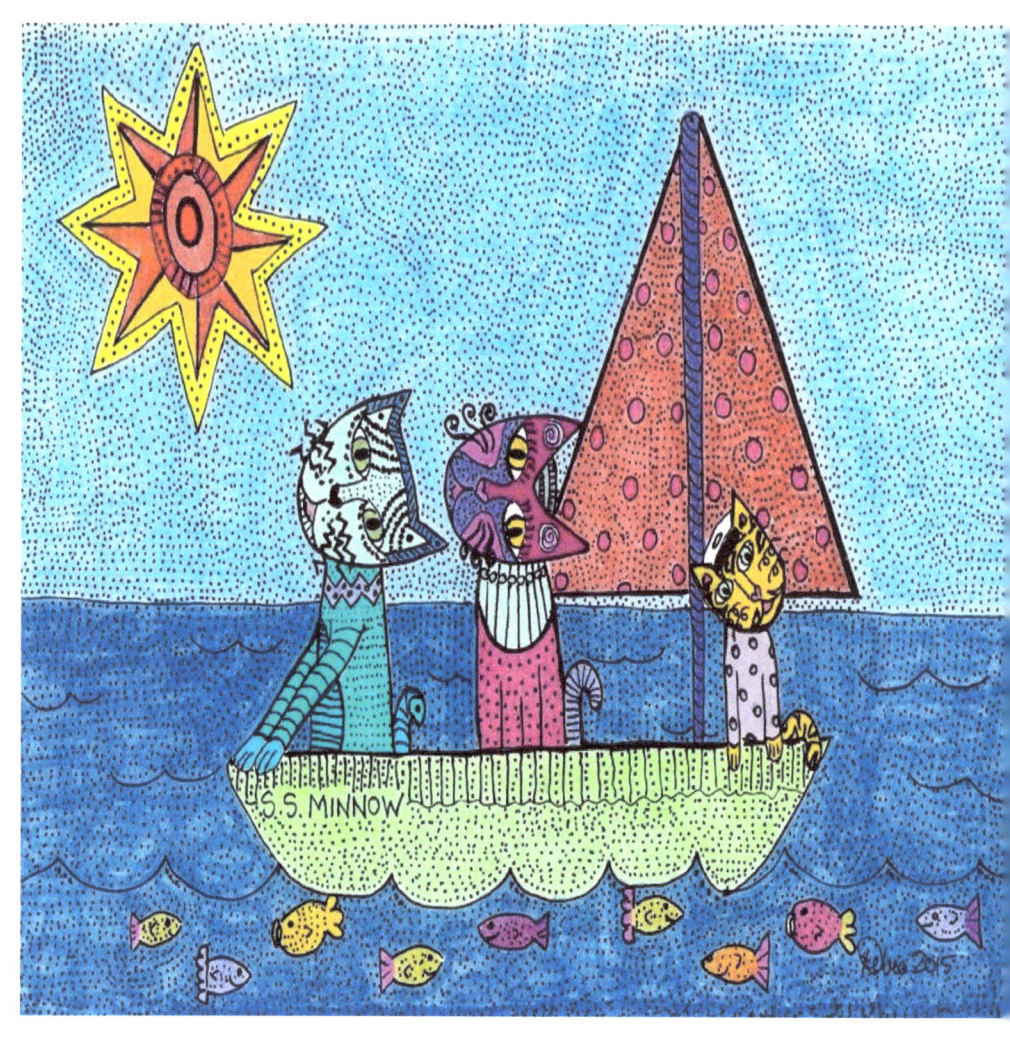

It was such a pleasant day

last Saturday

the Kitty family decided

to go for a sail.

Mr. and Mrs. and little Jay
jumped in the boat
and floated away.
All the little fishes
swam alongside
and the Kittys had an
enjoyable ride.
Nothing is more relaxing
than the fresh sea air
to take away all your
problems and cares.

THE END

About the Author

Debra Duff is an artist, creative writer and author who resides in Gulfport, Florida with her poodle and three cats.

Watch for *Glamour Girls*, the second in the series of *My (very) Colorful Cats.*

www.ingramcontent.com/pod-product-compliance
Lightning Source LLC
Chambersburg PA
CBHW040923180526
45159CB00002BA/582